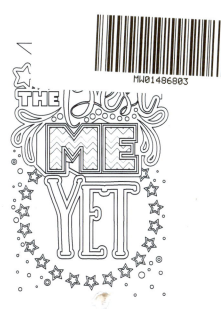

The Best Me Yet: Color-able Food & Fitness Tracker
By Gotta Jot It – Planners & Journals
©2018 Full Circle Arts, LLC Books

ISBN-13: 978-0-9989292-3-1
ISBN-10: 0-9989292-3-9

Inquiries? Please visit: www.facebook.com/GottaJotIt

Like us on Facebook and stay tuned for announcements for bonus pages.
Use code: BESTEVER

Please leave a review and let others know how this product has helped you!

This journal is not intended to replace the guidance of a medical professional. It is to be used as a supplement to your lifestyle program of choice. It is recommended that you consult with a doctor before beginning any diet or fitness program.

Do something therapeutic and enjoyable . . .
while you learn to better keep track of your health!
Use this journal along with any diet or exercise routine you follow!

HOW TO BEGIN USING THIS JOURNAL TO SUPPORT YOUR TRANSFORMATION JOURNEY:

- Record your beginning measurements in **The Measurement Keeper**
- Start plotting your info in the **Weight Progress Log**
- Add favorite foods to **Frequently Eaten Foods** for quick nutritional reference
- Decide what to eat! **Plan** your first week's meals and your **Shop!** list
- Set one small goal and begin to record your meals and snacks for each day
- As you progress, take note of your "macros" (proteins, fats, carbs) and your caloric intake vs. calories burned. Reflect on your choices daily.
- Color the **inspirational/motivational pages** when you need a therapeutic boost

* Once you have completed this 90-day journal, decide if you are ready to maintain your new lifestyle on your own, or if you would benefit by continuing on another 90-day journaling period to better reinforce these habits for life.

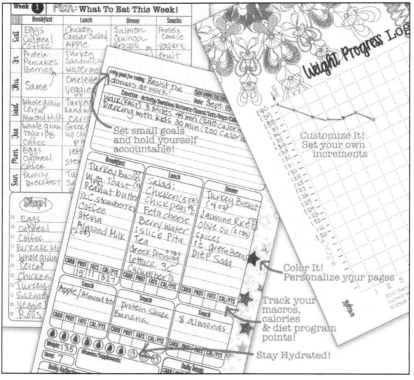

It is recommended that only pencils, colored pencils or colored ball point pens are used on double-sided logging pages. Markers and juicy gel pens may be used on single-sided inspirational coloring pages. To prevent bleeding, use a blotter page beneath, such as card stock. Drawing utensils are all different, so test your own supplies in an inconspicuous area to determine best use.

THE Best ME YET

THIS JOURNAL BELONGS TO:

 Use a protective blotter page here when coloring
with wet media on the reverse side of page

MY
Measurement Keeper

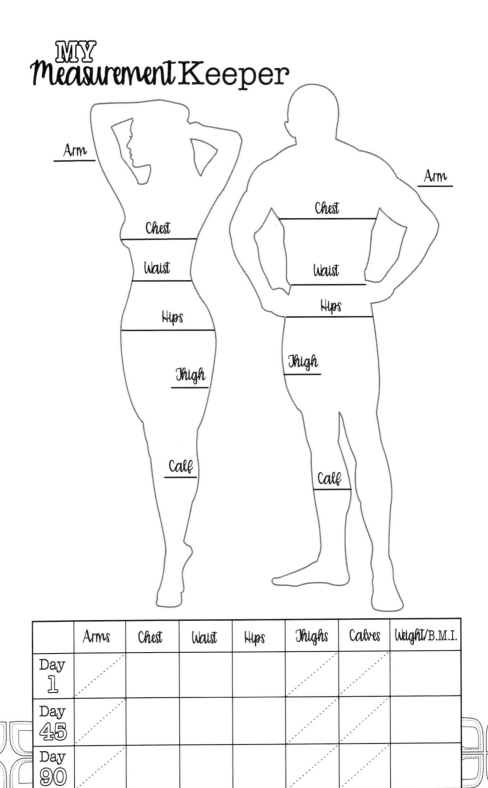

Arm ____

Chest

Waist

Hips

Thigh ____

Calf ____

Arm ____

Chest

Waist

Hips

Thigh ____

Calf ____

	Arms	Chest	Waist	Hips	Thighs	Calves	Weight/B.M.I.
Day 1							
Day 45							
Day 90							

Weight Progress Log

Start

weight

1 2 3 4 5 6 7 8 9 10 11 12

Week

Hint: Start by adding your current weight at the top to track weight loss or the bottom to track muscle gain.

Nutrition Reference: Frequently Eaten Foods

Fruits & Vegetables	AMOUNT	CARB	PROT	FATS	CAL/PTS

Grains	AMOUNT	CARB	PROT	FATS	CAL/PTS

Meats \| Poultry \| Fish \| Eggs \| Nuts Beans \| Vegetable Protein	AMOUNT	CARB	PROT	FATS	CAL/PTS

Nutrition Reference: Frequently Eaten Foods

MACROS

| Dairy | Yogurt | Cheese | AMOUNT | CARB | PROT | FATS | CAL/PTS |
|---|---|---|---|---|---|
| | | | | | |
| | | | | | |
| | | | | | |
| | | | | | |
| | | | | | |
| | | | | | |
| | | | | | |
| | | | | | |
| | | | | | |
| | | | | | |

| Fats | Oils | AMOUNT | CARB | PROT | FATS | CAL/PTS |
|---|---|---|---|---|---|
| | | | | | |
| | | | | | |
| | | | | | |
| | | | | | |
| | | | | | |
| | | | | | |
| | | | | | |

| Treats | Miscellaneous | AMOUNT | CARB | PROT | FATS | CAL/PTS |
|---|---|---|---|---|---|
| | | | | | |
| | | | | | |
| | | | | | |
| | | | | | |
| | | | | | |
| | | | | | |
| | | | | | |
| | | | | | |
| | | | | | |
| | | | | | |
| | | | | | |
| | | | | | |
| | | | | | |
| | | | | | |

Week 1 — Plan: What To Eat This Week!

	Breakfast	Lunch	Dinner	Snacks
Sat				
Fri				
Thu				
Wed				
Tue				
Mon				
Sun				

Shop!

- ○
- ○
- ○
- ○
- ○
- ○
- ○
- ○
- ○
- ○
- ○

- ○
- ○
- ○
- ○
- ○
- ○
- ○
- ○
- ○
- ○
- ○
- ○
- ○

- ○
- ○
- ○
- ○
- ○
- ○
- ○
- ○
- ○
- ○
- ○
- ○
- ○

Day 1	○ My goal for today:	SUN MON TUE WED THU FRI SAT
		Date:

Exercise - Activity/Duration/Distance/Speed/Sets/Reps/Calories Burned

..
..
..
..
..
..
..

Breakfast	Lunch	Dinner

CARB	PROT	FATS	CAL/PTS	CARB	PROT	FATS	CAL/PTS	CARB	PROT	FATS	CAL/PTS

Snack	Snack	Snack

CARB	PROT	FATS	CAL/PTS	CARB	PROT	FATS	CAL/PTS	CARB	PROT	FATS	CAL/PTS

Weight:

Sleep:

Vitamins/Supplements:

Daily Totals

CARB	PROT	FATS	CAL/PTS
After Exercise ▶			

Daily Reflection:

..
..

○ My goal for today: ..
.. Date: ..

| SUN | MON | TUE | WED | THU | FRI | SAT |

Day 2

Exercise - Activity/Duration/Distance/Speed/Sets/Reps/Calories Burned

...
...
...
...
...
...
...

Breakfast	Lunch	Dinner

CARB	PROT	FATS	CAL/PTS	CARB	PROT	FATS	CAL/PTS	CARB	PROT	FATS	CAL/PTS

Snack	Snack	Snack

CARB	PROT	FATS	CAL/PTS	CARB	PROT	FATS	CAL/PTS	CARB	PROT	FATS	CAL/PTS

Weight:

Sleep:

Vitamins/Supplements:

Daily Totals

CARB	PROT	FATS	CAL/PTS

After Exercise ▶

Daily Reflection:
...
...

Day 3	○ My goal for today: ...	SUN MON TUE WED THU FRI SAT
	...	Date: ...

Exercise - Activity/Duration/Distance/Speed/Sets/Reps/Calories Burned

..
..
..
..
..
..
..
..

Breakfast	Lunch	Dinner

CARB	PROT	FATS	CAL/PTS	CARB	PROT	FATS	CAL/PTS	CARB	PROT	FATS	CAL/PTS

Snack	Snack	Snack

CARB	PROT	FATS	CAL/PTS	CARB	PROT	FATS	CAL/PTS	CARB	PROT	FATS	CAL/PTS

Weight:

Sleep:

Vitamins/Supplements:

Daily Totals

CARB	PROT	FATS	CAL/PTS
After Exercise ▶			

Daily Reflection:

..
..

○ My goal for today:
.. Date:

SUN MON TUE WED THU FRI SAT

Day 4

Exercise - Activity/Duration/Distance/Speed/Sets/Reps/Calories Burned

..
..
..
..
..
..
..

Breakfast	Lunch	Dinner

CARB	PROT	FATS	CAL/PTS	CARB	PROT	FATS	CAL/PTS	CARB	PROT	FATS	CAL/PTS

Snack	Snack	Snack

CARB	PROT	FATS	CAL/PTS	CARB	PROT	FATS	CAL/PTS	CARB	PROT	FATS	CAL/PTS

Daily Totals

CARB	PROT	FATS	CAL/PTS

After Exercise ▶

Weight:

Sleep:

Vitamins/Supplements:

Daily Reflection:
..
..

Day 5	○ My goal for today:	SUN MON TUE WED THU FRI SAT
	...	Date:

Exercise - Activity/Duration/Distance/Speed/Sets/Reps/Calories Burned

..
..
..
..
..
..
..

Breakfast	Lunch	Dinner

CARB	PROT	FATS	CAL/PTS	CARB	PROT	FATS	CAL/PTS	CARB	PROT	FATS	CAL/PTS

Snack	Snack	Snack

CARB	PROT	FATS	CAL/PTS	CARB	PROT	FATS	CAL/PTS	CARB	PROT	FATS	CAL/PTS

Daily Totals

CARB	PROT	FATS	CAL/PTS
After Exercise ▶			

Weight:

Sleep:

Vitamins/Supplements:

Daily Reflection:

○ My goal for today: 　SUN　MON　TUE　WED　THU　FRI　SAT　　**Day 6**
.. Date:

Exercise - Activity/Duration/Distance/Speed/Sets/Reps/Calories Burned

...
...
...
...
...
...
...

Breakfast	Lunch	Dinner

CARB	PROT	FATS	CAL/PTS	CARB	PROT	FATS	CAL/PTS	CARB	PROT	FATS	CAL/PTS

Snack	Snack	Snack

CARB	PROT	FATS	CAL/PTS	CARB	PROT	FATS	CAL/PTS	CARB	PROT	FATS	CAL/PTS

○ ○ ○ ○ ○ ○ ○ ○ ○ ○

Weight:

Sleep:

Vitamins/Supplements:

Daily Totals

CARB	PROT	FATS	CAL/PTS
After Exercise ▶			

Daily Reflection:

...
...

Day 7	○ My goal for today:	SUN MON TUE WED THU FRI SAT
	Date:

Exercise - Activity/Duration/Distance/Speed/Sets/Reps/Calories Burned

Breakfast	Lunch	Dinner

CARB	PROT	FATS	CAL/PTS	CARB	PROT	FATS	CAL/PTS	CARB	PROT	FATS	CAL/PTS

Snack	Snack	Snack

CARB	PROT	FATS	CAL/PTS	CARB	PROT	FATS	CAL/PTS	CARB	PROT	FATS	CAL/PTS

Weight:

Sleep:

Vitamins/Supplements:

Daily Totals

CARB	PROT	FATS	CAL/PTS
After Exercise ▶			

Daily Reflection:

 Use a protective blotter page here when coloring
with wet media on the reverse side of page

Week ②	Plan: What To Eat This Week!

	Breakfast	Lunch	Dinner	Snacks
Sat				
Fri				
Thu				
Wed				
Tue				
Mon				
Sun				

Shop!

-
-
-
-
-
-
-
-
-
-
-
-
-
-
-
-
-
-
-
-
-
-
-
-
-
-
-
-

Day 8	○ My goal for today:	SUN MON TUE WED THU FRI SAT
	...	Date:

Exercise - Activity/Duration/Distance/Speed/Sets/Reps/Calories Burned

..
..
..
..
..
..
..
..
..

Breakfast	Lunch	Dinner

CARB	PROT	FATS	CAL/PTS	CARB	PROT	FATS	CAL/PTS	CARB	PROT	FATS	CAL/PTS

Snack	Snack	Snack

CARB	PROT	FATS	CAL/PTS	CARB	PROT	FATS	CAL/PTS	CARB	PROT	FATS	CAL/PTS

Daily Totals

CARB	PROT	FATS	CAL/PTS
After Exercise ▶			

Weight:

Sleep:

Vitamins/Supplements:

Daily Reflection:

..
..

○ My goal for today: | SUN | MON | TUE | WED | THU | FRI | SAT | **Day 9**
... Date:

Exercise - Activity/Duration/Distance/Speed/Sets/Reps/Calories Burned

...
...
...
...
...
...
...

Breakfast	Lunch	Dinner

CARB	PROT	FATS	CAL/PTS	CARB	PROT	FATS	CAL/PTS	CARB	PROT	FATS	CAL/PTS

Snack	Snack	Snack

CARB	PROT	FATS	CAL/PTS	CARB	PROT	FATS	CAL/PTS	CARB	PROT	FATS	CAL/PTS

Weight:

Sleep:

Vitamins/Supplements:

Daily Totals

CARB	PROT	FATS	CAL/PTS
After Exercise ▶			

Daily Reflection:

...
...

Day 10

○ My goal for today:

SUN MON TUE WED THU FRI SAT

Date:

Exercise - Activity/Duration/Distance/Speed/Sets/Reps/Calories Burned

Breakfast	Lunch	Dinner

CARB	PROT	FATS	CAL/PTS	CARB	PROT	FATS	CAL/PTS	CARB	PROT	FATS	CAL/PTS

Snack	Snack	Snack

CARB	PROT	FATS	CAL/PTS	CARB	PROT	FATS	CAL/PTS	CARB	PROT	FATS	CAL/PTS

Weight:

Sleep:

Vitamins/Supplements:

Daily Totals

CARB	PROT	FATS	CAL/PTS

After Exercise ▶

Daily Reflection:

○My goal for today: [SUN] [MON] [TUE] [WED] [THU] [FRI] [SAT] **Day 11**

.. Date: ..

Exercise - Activity/Duration/Distance/Speed/Sets/Reps/Calories Burned

...

...

...

...

...

...

...

...

Breakfast	Lunch	Dinner

CARB	PROT	FATS	CAL/PTS	CARB	PROT	FATS	CAL/PTS	CARB	PROT	FATS	CAL/PTS

Snack	Snack	Snack

CARB	PROT	FATS	CAL/PTS	CARB	PROT	FATS	CAL/PTS	CARB	PROT	FATS	CAL/PTS

○ ○ ○ ○ ○ ○ ○ ○ ○ ○

Weight:

Sleep:

Vitamins/Supplements:

Daily Totals

CARB	PROT	FATS	CAL/PTS
After Exercise ▶			

Daily Reflection:

...

...

Day 12 ○ My goal for today:

SUN MON TUE WED THU FRI SAT

Date:

Exercise - Activity/Duration/Distance/Speed/Sets/Reps/Calories Burned

..
..
..
..
..
..
..
..
..

Breakfast	Lunch	Dinner

CARB	PROT	FATS	CAL/PTS	CARB	PROT	FATS	CAL/PTS	CARB	PROT	FATS	CAL/PTS

Snack	Snack	Snack

CARB	PROT	FATS	CAL/PTS	CARB	PROT	FATS	CAL/PTS	CARB	PROT	FATS	CAL/PTS

Weight:

Sleep:

Vitamins/Supplements:

Daily Totals

CARB	PROT	FATS	CAL/PTS

After Exercise ▶

Daily Reflection: ...
..

○ My goal for today: SUN MON TUE WED THU FRI SAT **Day 13**
.. Date:

Exercise - Activity/Duration/Distance/Speed/Sets/Reps/Calories Burned

..
..
..
..
..
..
..

Breakfast	Lunch	Dinner

CARB	PROT	FATS	CAL/PTS	CARB	PROT	FATS	CAL/PTS	CARB	PROT	FATS	CAL/PTS

Snack	Snack	Snack

CARB	PROT	FATS	CAL/PTS	CARB	PROT	FATS	CAL/PTS	CARB	PROT	FATS	CAL/PTS

Weight:

Sleep:

Vitamins/Supplements:

Daily Totals

CARB	PROT	FATS	CAL/PTS

After Exercise ▶

Daily Reflection:
..
..

Day 14 ○ My goal for today:

SUN MON TUE WED THU FRI SAT

Date:

Exercise - Activity/Duration/Distance/Speed/Sets/Reps/Calories Burned

..
..
..
..
..
..
..
..

Breakfast	Lunch	Dinner

CARB	PROT	FATS	CAL/PTS	CARB	PROT	FATS	CAL/PTS	CARB	PROT	FATS	CAL/PTS

Snack	Snack	Snack

CARB	PROT	FATS	CAL/PTS	CARB	PROT	FATS	CAL/PTS	CARB	PROT	FATS	CAL/PTS

Weight:

Sleep:

Vitamins/Supplements:

Daily Totals

CARB	PROT	FATS	CAL/PTS
After Exercise ▶			

Daily Reflection:
..
..

Week **3**	Plan: What To Eat This Week!

	Breakfast	Lunch	Dinner	Snacks
Sat				
Fri				
Thu				
Wed				
Tue				
Mon				
Sun				

Shop!

Day 15	○ My goal for today:	SUN MON TUE WED THU FRI SAT
		Date:

Exercise - Activity/Duration/Distance/Speed/Sets/Reps/Calories Burned

...
...
...
...
...
...
...

Breakfast	Lunch	Dinner
....................
....................
....................
....................
....................
....................
....................
....................
....................

CARB	PROT	FATS	CAL/PTS	CARB	PROT	FATS	CAL/PTS	CARB	PROT	FATS	CAL/PTS

Snack	Snack	Snack
....................
....................

CARB	PROT	FATS	CAL/PTS	CARB	PROT	FATS	CAL/PTS	CARB	PROT	FATS	CAL/PTS

○ ○ ○ ○ ○ ○ ○ ○ ○ ○

Weight:

Sleep:

Vitamins/Supplements:

Daily Totals

CARB	PROT	FATS	CAL/PTS
After Exercise ▶			

Daily Reflection:
...
...

○ My goal for today:

SUN MON TUE WED THU FRI SAT

Date:

Day 16

Exercise - Activity/Duration/Distance/Speed/Sets/Reps/Calories Burned

..

..

..

..

..

..

..

Breakfast	Lunch	Dinner
..................................
..................................
..................................
..................................
..................................
..................................
..................................
..................................
..................................

CARB	PROT	FATS	CAL/PTS	CARB	PROT	FATS	CAL/PTS	CARB	PROT	FATS	CAL/PTS

Snack	Snack	Snack
..................................
..................................
..................................

CARB	PROT	FATS	CAL/PTS	CARB	PROT	FATS	CAL/PTS	CARB	PROT	FATS	CAL/PTS

◌ ◌ ◌ ◌ ◌ ◌ ◌ ◌ ◌ ◌

Weight:	Vitamins/Supplements:
Sleep:	

Daily Totals

CARB	PROT	FATS	CAL/PTS
After Exercise ▶			

Daily Reflection:

..

..

Day 17

○ My goal for today: ..

| SUN | MON | TUE | WED | THU | FRI | SAT |

Date: ..

Exercise - Activity/Duration/Distance/Speed/Sets/Reps/Calories Burned

..
..
..
..
..
..
..

Breakfast

CARB	PROT	FATS	CAL/PTS

Lunch

CARB	PROT	FATS	CAL/PTS

Dinner

CARB	PROT	FATS	CAL/PTS

Snack

CARB	PROT	FATS	CAL/PTS

Snack

CARB	PROT	FATS	CAL/PTS

Snack

CARB	PROT	FATS	CAL/PTS

Weight:

Sleep:

Vitamins/Supplements:

Daily Totals

CARB	PROT	FATS	CAL/PTS

After Exercise ▶

Daily Reflection:

..
..

○My goal for today: ...

.. Date:

SUN MON TUE WED THU FRI SAT

Day 18

Exercise - Activity/Duration/Distance/Speed/Sets/Reps/Calories Burned

...
...
...
...
...
...
...

Breakfast	Lunch	Dinner

CARB	PROT	FATS	CAL/PTS	CARB	PROT	FATS	CAL/PTS	CARB	PROT	FATS	CAL/PTS

Snack	Snack	Snack

CARB	PROT	FATS	CAL/PTS	CARB	PROT	FATS	CAL/PTS	CARB	PROT	FATS	CAL/PTS

Weight:

Sleep:

Vitamins/Supplements:

Daily Totals

CARB	PROT	FATS	CAL/PTS
After Exercise ▶			

Daily Reflection:
...
...

Day 19	○ My goal for today:	SUN MON TUE WED THU FRI SAT
	..	Date:

Exercise - Activity/Duration/Distance/Speed/Sets/Reps/Calories Burned

..
..
..
..
..
..
..

Breakfast	Lunch	Dinner
................................
................................
................................
................................
................................
................................
................................
................................
................................

CARB	PROT	FATS	CAL/PTS	CARB	PROT	FATS	CAL/PTS	CARB	PROT	FATS	CAL/PTS

Snack	Snack	Snack
................................
................................

CARB	PROT	FATS	CAL/PTS	CARB	PROT	FATS	CAL/PTS	CARB	PROT	FATS	CAL/PTS

○ ○ ○ ○ ○ ○ ○ ○ ○ ○

Weight:

Sleep:

Vitamins/Supplements:

Daily Totals

CARB	PROT	FATS	CAL/PTS
After Exercise ▶			

Daily Reflection: ..
..

○ My goal for today: SUN MON TUE WED THU FRI SAT **Day 20**

Date:

Exercise - Activity/Duration/Distance/Speed/Sets/Reps/Calories Burned

..
..
..
..
..
..
..
..

Breakfast	Lunch	Dinner

CARB	PROT	FATS	CAL/PTS	CARB	PROT	FATS	CAL/PTS	CARB	PROT	FATS	CAL/PTS

Snack	Snack	Snack

CARB	PROT	FATS	CAL/PTS	CARB	PROT	FATS	CAL/PTS	CARB	PROT	FATS	CAL/PTS

Weight:

Sleep:

Vitamins/Supplements:

Daily Totals

CARB	PROT	FATS	CAL/PTS

After Exercise ▶

Daily Reflection:

..
..

| Day **21** | ○ My goal for today: | SUN MON TUE WED THU FRI SAT |
| | ... | Date: |

Exercise - Activity/Duration/Distance/Speed/Sets/Reps/Calories Burned

..

..

..

..

..

..

..

Breakfast

CARB	PROT	FATS	CAL/PTS

Lunch

CARB	PROT	FATS	CAL/PTS

Dinner

CARB	PROT	FATS	CAL/PTS

Snack

CARB	PROT	FATS	CAL/PTS

Snack

CARB	PROT	FATS	CAL/PTS

Snack

CARB	PROT	FATS	CAL/PTS

Weight:

Sleep:

Vitamins/Supplements:

Daily Totals

CARB	PROT	FATS	CAL/PTS

After Exercise ▶

Daily Reflection:

..

..

 Use a protective blotter page here when coloring
with wet media on the reverse side of page

Plan: What To Eat This Week!

	Breakfast	Lunch	Dinner	Snacks
Sat				
Fri				
Thu				
Wed				
Tue				
Mon				
Sun				

Shop!

- ○
- ○
- ○
- ○
- ○
- ○
- ○
- ○
- ○
- ○

- ○
- ○
- ○
- ○
- ○
- ○
- ○
- ○
- ○
- ○
- ○
- ○

- ○
- ○
- ○
- ○
- ○
- ○
- ○
- ○
- ○
- ○
- ○
- ○

Day 22	○ My goal for today:	SUN MON TUE WED THU FRI SAT
		Date:

Exercise - Activity/Duration/Distance/Speed/Sets/Reps/Calories Burned

..

..

..

..

..

..

..

Breakfast	Lunch	Dinner
....................
....................
....................
....................
....................
....................
....................
....................
....................

CARB	PROT	FATS	CAL/PTS	CARB	PROT	FATS	CAL/PTS	CARB	PROT	FATS	CAL/PTS

Snack	Snack	Snack
....................
....................

CARB	PROT	FATS	CAL/PTS	CARB	PROT	FATS	CAL/PTS	CARB	PROT	FATS	CAL/PTS

Weight:

Sleep:

Vitamins/Supplements:

Daily Totals

CARB	PROT	FATS	CAL/PTS
After Exercise ▶			

Daily Reflection:

..

..

○ My goal for today: | SUN | MON | TUE | WED | THU | FRI | SAT | **Day 23**

Date:

Exercise - Activity/Duration/Distance/Speed/Sets/Reps/Calories Burned

...
...
...
...
...
...
...
...

Breakfast	Lunch	Dinner

CARB	PROT	FATS	CAL/PTS	CARB	PROT	FATS	CAL/PTS	CARB	PROT	FATS	CAL/PTS

Snack	Snack	Snack

CARB	PROT	FATS	CAL/PTS	CARB	PROT	FATS	CAL/PTS	CARB	PROT	FATS	CAL/PTS

Weight:

Sleep:

Vitamins/Supplements:

Daily Totals

CARB	PROT	FATS	CAL/PTS
After Exercise ▶			

Daily Reflection:

...
...

| Day 24 | ○ My goal for today: | SUN MON TUE WED THU FRI SAT |
| | | Date: |

Exercise - Activity/Duration/Distance/Speed/Sets/Reps/Calories Burned

..
..
..
..
..
..
..
..

Breakfast	Lunch	Dinner
...................
...................
...................
...................
...................
...................
...................
...................
...................
...................
...................

CARB	PROT	FATS	CAL/PTS	CARB	PROT	FATS	CAL/PTS	CARB	PROT	FATS	CAL/PTS

Snack	Snack	Snack
...................
...................
...................

CARB	PROT	FATS	CAL/PTS	CARB	PROT	FATS	CAL/PTS	CARB	PROT	FATS	CAL/PTS

○ ○ ○ ○ ○ ○ ○ ○ ○ ○ ○

Weight:

Sleep:

Vitamins/Supplements:

Daily Totals

CARB	PROT	FATS	CAL/PTS
After Exercise ▶			

Daily Reflection:
..
..

○ My goal for today:

... Date:

SUN MON TUE WED THU FRI SAT

Day 25

Exercise - Activity/Duration/Distance/Speed/Sets/Reps/Calories Burned

..

..

..

..

..

..

..

..

Breakfast	Lunch	Dinner

CARB	PROT	FATS	CAL/PTS	CARB	PROT	FATS	CAL/PTS	CARB	PROT	FATS	CAL/PTS

Snack	Snack	Snack

CARB	PROT	FATS	CAL/PTS	CARB	PROT	FATS	CAL/PTS	CARB	PROT	FATS	CAL/PTS

Weight:

Sleep:

Vitamins/Supplements:

Daily Totals

CARB	PROT	FATS	CAL/PTS

After Exercise ▶

Daily Reflection:

..

..

Day 26	○ My goal for today:	SUN MON TUE WED THU FRI SAT
	Date:	

Exercise - Activity/Duration/Distance/Speed/Sets/Reps/Calories Burned

..
..
..
..
..
..
..

Breakfast	Lunch	Dinner

CARB	PROT	FATS	CAL/PTS	CARB	PROT	FATS	CAL/PTS	CARB	PROT	FATS	CAL/PTS

Snack	Snack	Snack

CARB	PROT	FATS	CAL/PTS	CARB	PROT	FATS	CAL/PTS	CARB	PROT	FATS	CAL/PTS

Weight:

Sleep:

Vitamins/Supplements:

Daily Totals

CARB	PROT	FATS	CAL/PTS
After Exercise ▶			

Daily Reflection:

..
..

○ My goal for today:
Date:

SUN MON TUE WED THU FRI SAT

Day 27

Exercise - Activity/Duration/Distance/Speed/Sets/Reps/Calories Burned

..
..
..
..
..
..
..

Breakfast	Lunch	Dinner

CARB	PROT	FATS	CAL/PTS	CARB	PROT	FATS	CAL/PTS	CARB	PROT	FATS	CAL/PTS

Snack	Snack	Snack

CARB	PROT	FATS	CAL/PTS	CARB	PROT	FATS	CAL/PTS	CARB	PROT	FATS	CAL/PTS

Weight:

Sleep:

Vitamins/Supplements:

Daily Totals

CARB	PROT	FATS	CAL/PTS
After Exercise ▶			

Daily Reflection:

..
..

Day 28

○ My goal for today:

SUN MON TUE WED THU FRI SAT

Date:

Exercise - Activity/Duration/Distance/Speed/Sets/Reps/Calories Burned

..
..
..
..
..
..
..

Breakfast	Lunch	Dinner

CARB	PROT	FATS	CAL/PTS	CARB	PROT	FATS	CAL/PTS	CARB	PROT	FATS	CAL/PTS

Snack	Snack	Snack

CARB	PROT	FATS	CAL/PTS	CARB	PROT	FATS	CAL/PTS	CARB	PROT	FATS	CAL/PTS

Weight:

Sleep:

Vitamins/Supplements:

Daily Totals

CARB	PROT	FATS	CAL/PTS

After Exercise ▶

Daily Reflection:

..
..

	Breakfast	Lunch	Dinner	Snacks
Sat				
Fri				
Thu				
Wed				
Tue				
Mon				
Sun				

Week 5 — *Plan:* **What To Eat This Week!**

Shop!

- ○
- ○
- ○
- ○
- ○
- ○
- ○
- ○
- ○
- ○
- ○
- ○
- ○
- ○
- ○
- ○
- ○
- ○
- ○
- ○
- ○
- ○
- ○
- ○
- ○
- ○
- ○
- ○
- ○
- ○
- ○
- ○
- ○
- ○
- ○
- ○
- ○
- ○

Day 29	○ My goal for today: ..	SUN MON TUE WED THU FRI SAT
	..	Date:

Exercise - Activity/Duration/Distance/Speed/Sets/Reps/Calories Burned

..

..

..

..

..

..

..

Breakfast	Lunch	Dinner
....................
....................
....................
....................
....................
....................
....................
....................
....................
....................

CARB	PROT	FATS	CAL/PTS	CARB	PROT	FATS	CAL/PTS	CARB	PROT	FATS	CAL/PTS

Snack	Snack	Snack
....................
....................
....................

CARB	PROT	FATS	CAL/PTS	CARB	PROT	FATS	CAL/PTS	CARB	PROT	FATS	CAL/PTS

○ ○ ○ ○ ○ ○ ○ ○ ○ ○

Weight:

Sleep:

Vitamins/Supplements:

Daily Totals

CARB	PROT	FATS	CAL/PTS
After Exercise ▶			

Daily Reflection:

..

..

○My goal for today: SUN MON TUE WED THU FRI SAT **Day 30**
.. Date:

Exercise - Activity/Duration/Distance/Speed/Sets/Reps/Calories Burned

...
...
...
...
...
...
...

Breakfast	Lunch	Dinner

CARB	PROT	FATS	CAL/PTS	CARB	PROT	FATS	CAL/PTS	CARB	PROT	FATS	CAL/PTS

Snack	Snack	Snack

CARB	PROT	FATS	CAL/PTS	CARB	PROT	FATS	CAL/PTS	CARB	PROT	FATS	CAL/PTS

Weight:

Sleep:

Vitamins/Supplements:

Daily Totals

CARB	PROT	FATS	CAL/PTS

After Exercise ▶

Daily Reflection:
...
...

Day 31	○ My goal for today:	SUN MON TUE WED THU FRI SAT
	Date:	

Exercise - Activity/Duration/Distance/Speed/Sets/Reps/Calories Burned

..
..
..
..
..
..
..

Breakfast

CARB	PROT	FATS	CAL/PTS

Lunch

CARB	PROT	FATS	CAL/PTS

Dinner

CARB	PROT	FATS	CAL/PTS

Snack

CARB	PROT	FATS	CAL/PTS

Snack

CARB	PROT	FATS	CAL/PTS

Snack

CARB	PROT	FATS	CAL/PTS

Weight:

Sleep:

Vitamins/Supplements:

Daily Totals

	CARB	PROT	FATS	CAL/PTS
After Exercise ▶				

Daily Reflection: ...
..

○ My goal for today: ... | SUN | MON | TUE | WED | THU | FRI | SAT | **Day 32**

Date: ...

Exercise - Activity/Duration/Distance/Speed/Sets/Reps/Calories Burned

..
..
..
..
..
..
..

Breakfast	Lunch	Dinner

CARB	PROT	FATS	CAL/PTS	CARB	PROT	FATS	CAL/PTS	CARB	PROT	FATS	CAL/PTS

Snack	Snack	Snack

CARB	PROT	FATS	CAL/PTS	CARB	PROT	FATS	CAL/PTS	CARB	PROT	FATS	CAL/PTS

Weight:

Sleep:

Vitamins/Supplements:

Daily Totals

CARB	PROT	FATS	CAL/PTS
After Exercise ▶			

Daily Reflection: ..
..

Day 33	○ My goal for today:....................................	SUN MON TUE WED THU FRI SAT
	..	Date:

Exercise - Activity/Duration/Distance/Speed/Sets/Reps/Calories Burned

..

..

..

..

..

..

..

..

Breakfast	Lunch	Dinner

CARB	PROT	FATS	CAL/PTS	CARB	PROT	FATS	CAL/PTS	CARB	PROT	FATS	CAL/PTS

Snack	Snack	Snack

CARB	PROT	FATS	CAL/PTS	CARB	PROT	FATS	CAL/PTS	CARB	PROT	FATS	CAL/PTS

Weight:

Sleep:

Vitamins/Supplements:

Daily Totals

CARB	PROT	FATS	CAL/PTS

After Exercise ▶

Daily Reflection:

○ My goal for today:
..
Date:

SUN MON TUE WED THU FRI SAT

Day 34

Exercise - Activity/Duration/Distance/Speed/Sets/Reps/Calories Burned

...
...
...
...
...
...
...
...

Breakfast	Lunch	Dinner

CARB	PROT	FATS	CAL/PTS	CARB	PROT	FATS	CAL/PTS	CARB	PROT	FATS	CAL/PTS

Snack	Snack	Snack

CARB	PROT	FATS	CAL/PTS	CARB	PROT	FATS	CAL/PTS	CARB	PROT	FATS	CAL/PTS

Weight:

Sleep:

Vitamins/Supplements:

Daily Totals

CARB	PROT	FATS	CAL/PTS
After Exercise ▶			

Daily Reflection:
...
...

Day 35	○ My goal for today:.................................	SUN MON TUE WED THU FRI SAT
	Date:.................................	

Exercise - Activity/Duration/Distance/Speed/Sets/Reps/Calories Burned

..

..

..

..

..

..

..

Breakfast	Lunch	Dinner
....................
....................
....................
....................
....................
....................
....................
....................
....................
....................

CARB	PROT	FATS	CAL/PTS	CARB	PROT	FATS	CAL/PTS	CARB	PROT	FATS	CAL/PTS

Snack	Snack	Snack
....................
....................

CARB	PROT	FATS	CAL/PTS	CARB	PROT	FATS	CAL/PTS	CARB	PROT	FATS	CAL/PTS

○ ○ ○ ○ ○ ○ ○ ○ ○ ○

Weight:	Vitamins/Supplements:
Sleep:	

Daily Totals

CARB	PROT	FATS	CAL/PTS
After Exercise ▶			

Daily Reflection:

..

..

Use a protective blotter page here when coloring
with wet media on the reverse side of page

Week **6**	Plan: What To Eat This Week!			
	Breakfast	Lunch	Dinner	Snacks
Sat				
Fri				
Thu				
Wed				
Tue				
Mon				
Sun				

Shop!

○
○
○
○
○
○
○
○
○
○

○
○
○
○
○
○
○
○
○
○
○
○

○
○
○
○
○
○
○
○
○
○
○

Day 36	○ My goal for today:	SUN MON TUE WED THU FRI SAT
	...	Date:

Exercise - Activity/Duration/Distance/Speed/Sets/Reps/Calories Burned

..

..

..

..

..

..

..

Breakfast	Lunch	Dinner

CARB	PROT	FATS	CAL/PTS	CARB	PROT	FATS	CAL/PTS	CARB	PROT	FATS	CAL/PTS

Snack	Snack	Snack

CARB	PROT	FATS	CAL/PTS	CARB	PROT	FATS	CAL/PTS	CARB	PROT	FATS	CAL/PTS

Weight:

Sleep:

Vitamins/Supplements:

Daily Totals

CARB	PROT	FATS	CAL/PTS
After Exercise ▶			

Daily Reflection: ...

...

○ My goal for today: SUN MON TUE WED THU FRI SAT | **Day 37**

Date: ...

Exercise - Activity/Duration/Distance/Speed/Sets/Reps/Calories Burned

..

..

..

..

..

..

..

Breakfast	Lunch	Dinner
....................
....................
....................
....................
....................
....................
....................
....................
....................

CARB	PROT	FATS	CAL/PTS	CARB	PROT	FATS	CAL/PTS	CARB	PROT	FATS	CAL/PTS

Snack	Snack	Snack
....................
....................

CARB	PROT	FATS	CAL/PTS	CARB	PROT	FATS	CAL/PTS	CARB	PROT	FATS	CAL/PTS

⬡ ⬡ ⬡ ⬡ ⬡ ⬡ ⬡ ⬡ ⬡ ⬡

Daily Totals

CARB	PROT	FATS	CAL/PTS

Weight:

Vitamins/Supplements:

Sleep:

After Exercise ▶

Daily Reflection:

..

..

| Day 38 | ○ My goal for today: | SUN | MON | TUE | WED | THU | FRI | SAT |
| | | Date: | | | | | |

Exercise - Activity/Duration/Distance/Speed/Sets/Reps/Calories Burned

..

..

..

..

..

..

..

Breakfast	Lunch	Dinner

CARB	PROT	FATS	CAL/PTS	CARB	PROT	FATS	CAL/PTS	CARB	PROT	FATS	CAL/PTS

Snack	Snack	Snack

CARB	PROT	FATS	CAL/PTS	CARB	PROT	FATS	CAL/PTS	CARB	PROT	FATS	CAL/PTS

Weight:

Sleep:

Vitamins/Supplements:

Daily Totals

CARB	PROT	FATS	CAL/PTS
After Exercise ▶			

Daily Reflection:
..
..

○ My goal for today: SUN MON TUE WED THU FRI SAT | Day 39
................................... Date:

Exercise - Activity/Duration/Distance/Speed/Sets/Reps/Calories Burned

..
..
..
..
..
..
..
..

Breakfast	Lunch	Dinner

CARB	PROT	FATS	CAL/PTS	CARB	PROT	FATS	CAL/PTS	CARB	PROT	FATS	CAL/PTS

Snack	Snack	Snack

CARB	PROT	FATS	CAL/PTS	CARB	PROT	FATS	CAL/PTS	CARB	PROT	FATS	CAL/PTS

Weight:

Sleep:

Vitamins/Supplements:

Daily Totals

CARB	PROT	FATS	CAL/PTS

After Exercise ▶

Daily Reflection:

..
..

Day 40

○ My goal for today: ...

Date: ..

Exercise - Activity/Duration/Distance/Speed/Sets/Reps/Calories Burned

Breakfast	Lunch	Dinner

CARB	PROT	FATS	CAL/PTS	CARB	PROT	FATS	CAL/PTS	CARB	PROT	FATS	CAL/PTS

Snack	Snack	Snack

CARB	PROT	FATS	CAL/PTS	CARB	PROT	FATS	CAL/PTS	CARB	PROT	FATS	CAL/PTS

Weight:

Sleep:

Vitamins/Supplements:

Daily Totals

CARB	PROT	FATS	CAL/PTS
After Exercise ▶			

Daily Reflection:

○ My goal for today: .. [SUN] [MON] [TUE] [WED] [THU] [FRI] [SAT] **Day 41**

Date:

Exercise - Activity/Duration/Distance/Speed/Sets/Reps/Calories Burned

...
...
...
...
...
...
...
...

Breakfast	Lunch	Dinner

CARB	PROT	FATS	CAL/PTS	CARB	PROT	FATS	CAL/PTS	CARB	PROT	FATS	CAL/PTS

Snack	Snack	Snack

CARB	PROT	FATS	CAL/PTS	CARB	PROT	FATS	CAL/PTS	CARB	PROT	FATS	CAL/PTS

Weight:

Sleep:

Vitamins/Supplements:

Daily Totals

CARB	PROT	FATS	CAL/PTS

After Exercise ▶

Daily Reflection:
...
...

Day 42	○ My goal for today:	SUN MON TUE WED THU FRI SAT
		Date:

Exercise - Activity/Duration/Distance/Speed/Sets/Reps/Calories Burned

..
..
..
..
..
..
..
..

Breakfast	Lunch	Dinner
....................
....................
....................
....................
....................
....................
....................
....................
....................
....................
....................

CARB	PROT	FATS	CAL/PTS	CARB	PROT	FATS	CAL/PTS	CARB	PROT	FATS	CAL/PTS

Snack	Snack	Snack
....................
....................

CARB	PROT	FATS	CAL/PTS	CARB	PROT	FATS	CAL/PTS	CARB	PROT	FATS	CAL/PTS

○ ○ ○ ○ ○ ○ ○ ○ ○ ○

Weight:	Vitamins/Supplements:
Sleep:	

Daily Totals

CARB	PROT	FATS	CAL/PTS
After Exercise ▶			

Daily Reflection: ..
..

Week **7** | Plan : **What To Eat This Week!**

	Breakfast	Lunch	Dinner	Snacks
Sat				
Fri				
Thu				
Wed				
Tue				
Mon				
Sun				

Shop!

- ○
- ○
- ○
- ○
- ○
- ○
- ○
- ○
- ○
- ○

- ○
- ○
- ○
- ○
- ○
- ○
- ○
- ○
- ○
- ○
- ○
- ○
- ○

- ○
- ○
- ○
- ○
- ○
- ○
- ○
- ○
- ○
- ○
- ○
- ○
- ○

| Day **43** | ○ My goal for today: | SUN MON TUE WED THU FRI SAT |
| | ... | Date: |

Exercise - Activity/Duration/Distance/Speed/Sets/Reps/Calories Burned

...
...
...
...
...
...
...

Breakfast	Lunch	Dinner

CARB	PROT	FATS	CAL/PTS	CARB	PROT	FATS	CAL/PTS	CARB	PROT	FATS	CAL/PTS

Snack	Snack	Snack

CARB	PROT	FATS	CAL/PTS	CARB	PROT	FATS	CAL/PTS	CARB	PROT	FATS	CAL/PTS

Weight:

Sleep:

Vitamins/Supplements:

Daily Totals

CARB	PROT	FATS	CAL/PTS
After Exercise ▶			

Daily Reflection: ..
...

○ My goal for today: [SUN] [MON] [TUE] [WED] [THU] [FRI] [SAT] | **Day 44**

Date:

Exercise - Activity/Duration/Distance/Speed/Sets/Reps/Calories Burned

Breakfast	Lunch	Dinner

CARB	PROT	FATS	CAL/PTS	CARB	PROT	FATS	CAL/PTS	CARB	PROT	FATS	CAL/PTS

Snack	Snack	Snack

CARB	PROT	FATS	CAL/PTS	CARB	PROT	FATS	CAL/PTS	CARB	PROT	FATS	CAL/PTS

Weight:

Sleep:

Vitamins/Supplements:

Daily Totals

CARB	PROT	FATS	CAL/PTS
After Exercise ▶			

Daily Reflection:

Day 45
halfway

○ My goal for today:

SUN MON TUE WED THU FRI SAT

Date:

Exercise - Activity/Duration/Distance/Speed/Sets/Reps/Calories Burned

......................................
......................................
......................................
......................................
......................................
......................................
......................................

Breakfast	Lunch	Dinner

CARB	PROT	FATS	CAL/PTS	CARB	PROT	FATS	CAL/PTS	CARB	PROT	FATS	CAL/PTS

Snack	Snack	Snack

CARB	PROT	FATS	CAL/PTS	CARB	PROT	FATS	CAL/PTS	CARB	PROT	FATS	CAL/PTS

Weight:

Sleep:

Vitamins/Supplements:

Daily Totals

CARB	PROT	FATS	CAL/PTS
After Exercise ▶			

Daily Reflection:
......................................
......................................

○ My goal for today: SUN MON TUE WED THU FRI SAT

Date: **Day 46**

Exercise - Activity/Duration/Distance/Speed/Sets/Reps/Calories Burned

..
..
..
..
..
..
..

Breakfast	Lunch	Dinner

CARB	PROT	FATS	CAL/PTS	CARB	PROT	FATS	CAL/PTS	CARB	PROT	FATS	CAL/PTS

Snack	Snack	Snack

CARB	PROT	FATS	CAL/PTS	CARB	PROT	FATS	CAL/PTS	CARB	PROT	FATS	CAL/PTS

Weight:

Sleep:

Vitamins/Supplements:

Daily Totals

CARB	PROT	FATS	CAL/PTS

After Exercise ▶

Daily Reflection:

..
..

Day 47	○ My goal for today: ..	SUN MON TUE WED THU FRI SAT
		Date: ..

Exercise - Activity/Duration/Distance/Speed/Sets/Reps/Calories Burned

..
..
..
..
..
..

Breakfast	Lunch	Dinner
...........................
...........................
...........................
...........................
...........................
...........................
...........................
...........................
...........................
...........................

CARB	PROT	FATS	CAL/PTS	CARB	PROT	FATS	CAL/PTS	CARB	PROT	FATS	CAL/PTS

Snack	Snack	Snack
...........................
...........................

CARB	PROT	FATS	CAL/PTS	CARB	PROT	FATS	CAL/PTS	CARB	PROT	FATS	CAL/PTS

○ ○ ○ ○ ○ ○ ○ ○ ○ ○

Weight:	Vitamins/Supplements:
Sleep:	

Daily Totals

CARB	PROT	FATS	CAL/PTS
After Exercise ▶			

Daily Reflection:
..
..

○ My goal for today: [SUN] [MON] [TUE] [WED] [THU] [FRI] [SAT] | **Day 48**
.. Date:

Exercise - Activity/Duration/Distance/Speed/Sets/Reps/Calories Burned

Breakfast	Lunch	Dinner

CARB	PROT	FATS	CAL/PTS	CARB	PROT	FATS	CAL/PTS	CARB	PROT	FATS	CAL/PTS

Snack	Snack	Snack

CARB	PROT	FATS	CAL/PTS	CARB	PROT	FATS	CAL/PTS	CARB	PROT	FATS	CAL/PTS

Weight:

Sleep:

Vitamins/Supplements:

Daily Totals

CARB	PROT	FATS	CAL/PTS

After Exercise ▶

Daily Reflection:

Day 49

○ My goal for today: ..

SUN MON TUE WED THU FRI SAT

Date: ..

Exercise - Activity/Duration/Distance/Speed/Sets/Reps/Calories Burned

..
..
..
..
..

Breakfast	Lunch	Dinner

CARB	PROT	FATS	CAL/PTS	CARB	PROT	FATS	CAL/PTS	CARB	PROT	FATS	CAL/PTS

Snack	Snack	Snack

CARB	PROT	FATS	CAL/PTS	CARB	PROT	FATS	CAL/PTS	CARB	PROT	FATS	CAL/PTS

Weight:

Sleep:

Vitamins/Supplements:

Daily Totals

CARB	PROT	FATS	CAL/PTS

After Exercise ▶

Daily Reflection:
..
..

 Use a protective blotter page here when coloring
with wet media on the reverse side of page

Week **8**	Plan: **What To Eat This Week!**

	Breakfast	Lunch	Dinner	Snacks
Sat				
Fri				
Thu				
Wed				
Tue				
Mon				
Sun				

Shop!

○
○
○
○
○
○
○
○
○
○

○
○
○
○
○
○
○
○
○
○
○
○

○
○
○
○
○
○
○
○
○
○
○
○

Day 50

○ My goal for today:
Date:

SUN MON TUE WED THU FRI SAT

Exercise - Activity/Duration/Distance/Speed/Sets/Reps/Calories Burned

Breakfast	Lunch	Dinner

CARB	PROT	FATS	CAL/PTS	CARB	PROT	FATS	CAL/PTS	CARB	PROT	FATS	CAL/PTS

Snack	Snack	Snack

CARB	PROT	FATS	CAL/PTS	CARB	PROT	FATS	CAL/PTS	CARB	PROT	FATS	CAL/PTS

Weight:

Sleep:

Vitamins/Supplements:

Daily Totals

CARB	PROT	FATS	CAL/PTS
After Exercise ▶			

Daily Reflection:

○ My goal for today:

| SUN | MON | TUE | WED | THU | FRI | SAT |

Day **51**

Date: ..

Exercise - Activity/Duration/Distance/Speed/Sets/Reps/Calories Burned

..
..
..
..
..
..
..
..

Breakfast	Lunch	Dinner

CARB	PROT	FATS	CAL/PTS	CARB	PROT	FATS	CAL/PTS	CARB	PROT	FATS	CAL/PTS

Snack	Snack	Snack

CARB	PROT	FATS	CAL/PTS	CARB	PROT	FATS	CAL/PTS	CARB	PROT	FATS	CAL/PTS

Weight:

Sleep:

Vitamins/Supplements:

Daily Totals

CARB	PROT	FATS	CAL/PTS
After Exercise ▶			

Daily Reflection:

..
..

Day 52

○ My goal for today: ...

Date: ...

SUN | MON | TUE | WED | THU | FRI | SAT

Exercise - Activity/Duration/Distance/Speed/Sets/Reps/Calories Burned

...
...
...
...
...
...

Breakfast	Lunch	Dinner

CARB	PROT	FATS	CAL/PTS	CARB	PROT	FATS	CAL/PTS	CARB	PROT	FATS	CAL/PTS

Snack	Snack	Snack

CARB	PROT	FATS	CAL/PTS	CARB	PROT	FATS	CAL/PTS	CARB	PROT	FATS	CAL/PTS

Weight:

Sleep:

Vitamins/Supplements:

Daily Totals

CARB	PROT	FATS	CAL/PTS

After Exercise ▶

Daily Reflection: ...
...

○ My goal for today: | SUN | MON | TUE | WED | THU | FRI | SAT | **Day 53**
.. Date:

Exercise - Activity/Duration/Distance/Speed/Sets/Reps/Calories Burned

..

..

..

..

..

..

..

Breakfast	Lunch	Dinner

CARB	PROT	FATS	CAL/PTS	CARB	PROT	FATS	CAL/PTS	CARB	PROT	FATS	CAL/PTS

Snack	Snack	Snack

CARB	PROT	FATS	CAL/PTS	CARB	PROT	FATS	CAL/PTS	CARB	PROT	FATS	CAL/PTS

Weight:

Sleep:

Vitamins/Supplements:

Daily Totals

CARB	PROT	FATS	CAL/PTS

After Exercise ▶

Daily Reflection:

..

..

Day 54

○ My goal for today:
...
Date:

SUN MON TUE WED THU FRI SAT

Exercise - Activity/Duration/Distance/Speed/Sets/Reps/Calories Burned

Breakfast	Lunch	Dinner

CARB	PROT	FATS	CAL/PTS	CARB	PROT	FATS	CAL/PTS	CARB	PROT	FATS	CAL/PTS

Snack	Snack	Snack

CARB	PROT	FATS	CAL/PTS	CARB	PROT	FATS	CAL/PTS	CARB	PROT	FATS	CAL/PTS

Weight:

Sleep:

Vitamins/Supplements:

Daily Totals

CARB	PROT	FATS	CAL/PTS
After Exercise ▶			

Daily Reflection:
...
...

○ My goal for today: [SUN] [MON] [TUE] [WED] [THU] [FRI] [SAT] **Day 55**

.. Date:

Exercise - Activity/Duration/Distance/Speed/Sets/Reps/Calories Burned

..
..
..
..
..
..
..
..

Breakfast				Lunch				Dinner			
CARB	PROT	FATS	CAL/PTS	CARB	PROT	FATS	CAL/PTS	CARB	PROT	FATS	CAL/PTS

Snack				Snack				Snack			
CARB	PROT	FATS	CAL/PTS	CARB	PROT	FATS	CAL/PTS	CARB	PROT	FATS	CAL/PTS

(○) (○) (○) (○) (○) (○) (○) (○) (○) (○)

Weight:	Vitamins/Supplements:
Sleep:	

Daily Totals

CARB	PROT	FATS	CAL/PTS
After Exercise ▶			

Daily Reflection:

..
..

Day 56

○ My goal for today: ...

SUN MON TUE WED THU FRI SAT

Date:

Exercise - Activity/Duration/Distance/Speed/Sets/Reps/Calories Burned

..
..
..
..
..
..
..

Breakfast				Lunch				Dinner			
CARB	PROT	FATS	CAL/PTS	CARB	PROT	FATS	CAL/PTS	CARB	PROT	FATS	CAL/PTS

Snack				Snack				Snack			
CARB	PROT	FATS	CAL/PTS	CARB	PROT	FATS	CAL/PTS	CARB	PROT	FATS	CAL/PTS

Weight:

Sleep:

Vitamins/Supplements:

Daily Totals

CARB	PROT	FATS	CAL/PTS
After Exercise ▶			

Daily Reflection:

..
..

Week **9**	Plan: What To Eat This Week!			
	Breakfast	Lunch	Dinner	Snacks
Sat				
Fri				
Thu				
Wed				
Tue				
Mon				
Sun				

Shop!

○ _____
○ _____
○ _____
○ _____
○ _____
○ _____
○ _____
○ _____
○ _____
○ _____
○ _____
○ _____

○ _____
○ _____
○ _____
○ _____
○ _____
○ _____
○ _____
○ _____
○ _____
○ _____
○ _____
○ _____
○ _____

○ _____
○ _____
○ _____
○ _____
○ _____
○ _____
○ _____
○ _____
○ _____
○ _____
○ _____
○ _____
○ _____

Day 57	○ My goal for today:	SUN MON TUE WED THU FRI SAT
	Date:

Exercise - Activity/Duration/Distance/Speed/Sets/Reps/Calories Burned

..
..
..
..
..
..

Breakfast	Lunch	Dinner
...............
...............
...............
...............
...............
...............
...............
...............
...............

CARB	PROT	FATS	CAL/PTS	CARB	PROT	FATS	CAL/PTS	CARB	PROT	FATS	CAL/PTS

Snack	Snack	Snack
...............
...............

CARB	PROT	FATS	CAL/PTS	CARB	PROT	FATS	CAL/PTS	CARB	PROT	FATS	CAL/PTS

○ ○ ○ ○ ○ ○ ○ ○ ○ ○

Weight:	Vitamins/Supplements:
Sleep:	

Daily Totals

CARB	PROT	FATS	CAL/PTS
After Exercise ▶			

Daily Reflection: ...
..

○ My goal for today: [SUN] [MON] [TUE] [WED] [THU] [FRI] [SAT] **Day 58**

Date:

Exercise - Activity/Duration/Distance/Speed/Sets/Reps/Calories Burned

Breakfast

CARB	PROT	FATS	CAL/PTS

Lunch

CARB	PROT	FATS	CAL/PTS

Dinner

CARB	PROT	FATS	CAL/PTS

Snack

CARB	PROT	FATS	CAL/PTS

Snack

CARB	PROT	FATS	CAL/PTS

Snack

CARB	PROT	FATS	CAL/PTS

Weight:

Sleep:

Vitamins/Supplements:

Daily Totals

CARB	PROT	FATS	CAL/PTS
After Exercise ▶			

Daily Reflection:

Day 59

○ My goal for today: ...
Date: ...

SUN | MON | TUE | WED | THU | FRI | SAT

Exercise - Activity/Duration/Distance/Speed/Sets/Reps/Calories Burned

..
..
..
..
..
..

Breakfast	Lunch	Dinner

CARB	PROT	FATS	CAL/PTS	CARB	PROT	FATS	CAL/PTS	CARB	PROT	FATS	CAL/PTS

Snack	Snack	Snack

CARB	PROT	FATS	CAL/PTS	CARB	PROT	FATS	CAL/PTS	CARB	PROT	FATS	CAL/PTS

Weight:

Sleep:

Vitamins/Supplements:

Daily Totals

CARB	PROT	FATS	CAL/PTS
After Exercise ▶			

Daily Reflection: ...
..

○My goal for today: .. [SUN] [MON] [TUE] [WED] [THU] [FRI] [SAT] | Day 60

.. Date:

Exercise - Activity/Duration/Distance/Speed/Sets/Reps/Calories Burned

...

...

...

...

...

...

Breakfast	Lunch	Dinner

CARB	PROT	FATS	CAL/PTS	CARB	PROT	FATS	CAL/PTS	CARB	PROT	FATS	CAL/PTS

Snack	Snack	Snack

CARB	PROT	FATS	CAL/PTS	CARB	PROT	FATS	CAL/PTS	CARB	PROT	FATS	CAL/PTS

◯ ◯ ◯ ◯ ◯ ◯ ◯ ◯ ◯ ◯

Weight:	Vitamins/Supplements:
Sleep:	

Daily Totals

CARB	PROT	FATS	CAL/PTS
After Exercise ▶			

Daily Reflection:

...

...

Day 61

○ My goal for today: ...

Date: ...

Exercise - Activity/Duration/Distance/Speed/Sets/Reps/Calories Burned

...
...
...
...
...
...

Breakfast	Lunch	Dinner

CARB	PROT	FATS	CAL/PTS	CARB	PROT	FATS	CAL/PTS	CARB	PROT	FATS	CAL/PTS

Snack	Snack	Snack

CARB	PROT	FATS	CAL/PTS	CARB	PROT	FATS	CAL/PTS	CARB	PROT	FATS	CAL/PTS

Weight:

Sleep:

Vitamins/Supplements:

Daily Totals

CARB	PROT	FATS	CAL/PTS

After Exercise ▶

Daily Reflection:
...
...

○ My goal for today: [SUN] [MON] [TUE] [WED] [THU] [FRI] [SAT] | **Day 62**

.. Date: ..

Exercise - Activity/Duration/Distance/Speed/Sets/Reps/Calories Burned

...

...

...

...

...

...

...

Breakfast	Lunch	Dinner

CARB	PROT	FATS	CAL/PTS	CARB	PROT	FATS	CAL/PTS	CARB	PROT	FATS	CAL/PTS

Snack	Snack	Snack

CARB	PROT	FATS	CAL/PTS	CARB	PROT	FATS	CAL/PTS	CARB	PROT	FATS	CAL/PTS

○ ○ ○ ○ ○ ○ ○ ○ ○ ○

Weight:	Vitamins/Supplements:
Sleep:	

Daily Totals

CARB	PROT	FATS	CAL/PTS

After Exercise ▶

Daily Reflection:

...

...

Day 63

My goal for today:

SUN MON TUE WED THU FRI SAT

Date:

Exercise - Activity/Duration/Distance/Speed/Sets/Reps/Calories Burned

	Breakfast					Lunch					Dinner		
CARB	PROT	FATS	CAL/PTS	CARB	PROT	FATS	CAL/PTS	CARB	PROT	FATS	CAL/PTS		

	Snack					Snack					Snack		
CARB	PROT	FATS	CAL/PTS	CARB	PROT	FATS	CAL/PTS	CARB	PROT	FATS	CAL/PTS		

Weight:

Sleep:

Vitamins/Supplements:

Daily Totals

CARB	PROT	FATS	CAL/PTS
After Exercise ▶			

Daily Reflection:

Use a protective blotter page here when coloring
with wet media on the reverse side of page

Plan: What To Eat This Week!

	Breakfast	Lunch	Dinner	Snacks
Sat				
Fri				
Thu				
Wed				
Tue				
Mon				
Sun				

Shop!

Day 64

○ My goal for today:
.................................
Date:

SUN | MON | TUE | WED | THU | FRI | SAT

Exercise - Activity/Duration/Distance/Speed/Sets/Reps/Calories Burned

.................................
.................................
.................................
.................................
.................................
.................................
.................................
.................................

Breakfast	Lunch	Dinner

CARB	PROT	FATS	CAL/PTS	CARB	PROT	FATS	CAL/PTS	CARB	PROT	FATS	CAL/PTS

Snack	Snack	Snack

CARB	PROT	FATS	CAL/PTS	CARB	PROT	FATS	CAL/PTS	CARB	PROT	FATS	CAL/PTS

Weight:

Sleep:

Vitamins/Supplements:

Daily Totals

CARB	PROT	FATS	CAL/PTS
After Exercise ▶			

Daily Reflection:
.................................
.................................

○ My goal for today: SUN MON TUE WED THU FRI SAT **Day 65**

Date:

Exercise - Activity/Duration/Distance/Speed/Sets/Reps/Calories Burned

..
..
..
..
..
..
..
..

Breakfast	Lunch	Dinner
..........................
..........................
..........................
..........................
..........................
..........................
..........................
..........................

CARB	PROT	FATS	CAL/PTS	CARB	PROT	FATS	CAL/PTS	CARB	PROT	FATS	CAL/PTS

Snack	Snack	Snack
..........................
..........................

CARB	PROT	FATS	CAL/PTS	CARB	PROT	FATS	CAL/PTS	CARB	PROT	FATS	CAL/PTS

Weight:

Sleep:

Vitamins/Supplements:

Daily Totals

CARB	PROT	FATS	CAL/PTS
After Exercise ▶			

Daily Reflection:

..
..

Day 66　　○ My goal for today:

SUN　MON　TUE　WED　THU　FRI　SAT

Date: ...

Exercise - Activity/Duration/Distance/Speed/Sets/Reps/Calories Burned

Breakfast	Lunch	Dinner

CARB	PROT	FATS	CAL/PTS	CARB	PROT	FATS	CAL/PTS	CARB	PROT	FATS	CAL/PTS

Snack	Snack	Snack

CARB	PROT	FATS	CAL/PTS	CARB	PROT	FATS	CAL/PTS	CARB	PROT	FATS	CAL/PTS

Weight:

Sleep:

Vitamins/Supplements:

Daily Totals

CARB	PROT	FATS	CAL/PTS
After Exercise ▶			

Daily Reflection:

○ My goal for today: [SUN] [MON] [TUE] [WED] [THU] [FRI] [SAT] **Day 67**

.. Date:

Exercise - Activity/Duration/Distance/Speed/Sets/Reps/Calories Burned

..

..

..

..

..

..

..

Breakfast	Lunch	Dinner

CARB	PROT	FATS	CAL/PTS	CARB	PROT	FATS	CAL/PTS	CARB	PROT	FATS	CAL/PTS

Snack	Snack	Snack

CARB	PROT	FATS	CAL/PTS	CARB	PROT	FATS	CAL/PTS	CARB	PROT	FATS	CAL/PTS

◌ ◌ ◌ ◌ ◌ ◌ ◌ ◌ ◌ ◌

Weight:

Sleep:

Vitamins/Supplements:

Daily Totals

CARB	PROT	FATS	CAL/PTS
After Exercise ▶			

Daily Reflection:

..

..

Day 68

My goal for today: ...
..

Date:

Exercise - Activity/Duration/Distance/Speed/Sets/Reps/Calories Burned

...
...
...
...
...
...
...
...

Breakfast	Lunch	Dinner

CARB	PROT	FATS	CAL/PTS	CARB	PROT	FATS	CAL/PTS	CARB	PROT	FATS	CAL/PTS

Snack	Snack	Snack

CARB	PROT	FATS	CAL/PTS	CARB	PROT	FATS	CAL/PTS	CARB	PROT	FATS	CAL/PTS

Weight:

Sleep:

Vitamins/Supplements:

Daily Totals

CARB	PROT	FATS	CAL/PTS

After Exercise ▶

Daily Reflection:
..
..

○ My goal for today: [SUN] [MON] [TUE] [WED] [THU] [FRI] [SAT]

Date: **Day 69**

Exercise - Activity/Duration/Distance/Speed/Sets/Reps/Calories Burned

Breakfast	Lunch	Dinner

CARB	PROT	FATS	CAL/PTS	CARB	PROT	FATS	CAL/PTS	CARB	PROT	FATS	CAL/PTS

Snack	Snack	Snack

CARB	PROT	FATS	CAL/PTS	CARB	PROT	FATS	CAL/PTS	CARB	PROT	FATS	CAL/PTS

◌ ◌ ◌ ◌ ◌ ◌ ◌ ◌ ◌ ◌

Weight:

Sleep:

Vitamins/Supplements:

Daily Totals

CARB	PROT	FATS	CAL/PTS

After Exercise ▶

Daily Reflection:

Day 70

○ My goal for today: ..

...

| SUN | MON | TUE | WED | THU | FRI | SAT |

Date: ..

Exercise - Activity/Duration/Distance/Speed/Sets/Reps/Calories Burned

...
...
...
...
...
...

Breakfast

CARB	PROT	FATS	CAL/PTS

Lunch

CARB	PROT	FATS	CAL/PTS

Dinner

CARB	PROT	FATS	CAL/PTS

Snack

CARB	PROT	FATS	CAL/PTS

Snack

CARB	PROT	FATS	CAL/PTS

Snack

CARB	PROT	FATS	CAL/PTS

Weight:

Sleep:

Vitamins/Supplements:

Daily Totals

CARB	PROT	FATS	CAL/PTS

After Exercise ▶

Daily Reflection:

| Week 11 | Plan: What To Eat This Week! |
	Breakfast	Lunch	Dinner	Snacks
Sat				
Fri				
Thu				
Wed				
Tue				
Mon				
Sun				

Shop!

Day 71	○ My goal for today:	SUN MON TUE WED THU FRI SAT
		Date:

Exercise - Activity/Duration/Distance/Speed/Sets/Reps/Calories Burned

..

..

..

..

..

..

Breakfast	Lunch	Dinner

CARB	PROT	FATS	CAL/PTS

CARB	PROT	FATS	CAL/PTS

CARB	PROT	FATS	CAL/PTS

Snack	Snack	Snack

CARB	PROT	FATS	CAL/PTS

CARB	PROT	FATS	CAL/PTS

CARB	PROT	FATS	CAL/PTS

Weight:

Sleep:

Vitamins/Supplements:

Daily Totals

CARB	PROT	FATS	CAL/PTS

After Exercise ▶

Daily Reflection:

..

..

○ My goal for today: SUN MON TUE WED THU FRI SAT **Day 72**
.. Date:

Exercise - Activity/Duration/Distance/Speed/Sets/Reps/Calories Burned

..
..
..
..
..
..
..

Breakfast	Lunch	Dinner

CARB	PROT	FATS	CAL/PTS	CARB	PROT	FATS	CAL/PTS	CARB	PROT	FATS	CAL/PTS

Snack	Snack	Snack

CARB	PROT	FATS	CAL/PTS	CARB	PROT	FATS	CAL/PTS	CARB	PROT	FATS	CAL/PTS

Weight:

Sleep:

Vitamins/Supplements:

Daily Totals

CARB	PROT	FATS	CAL/PTS
After Exercise ▶			

Daily Reflection:

..
..

Day 73	○ My goal for today:............................	SUN MON TUE WED THU FRI SAT
		Date:..........................

Exercise - Activity/Duration/Distance/Speed/Sets/Reps/Calories Burned

..
..
..
..
..
..

Breakfast	Lunch	Dinner

CARB	PROT	FATS	CAL/PTS	CARB	PROT	FATS	CAL/PTS	CARB	PROT	FATS	CAL/PTS

Snack	Snack	Snack

CARB	PROT	FATS	CAL/PTS	CARB	PROT	FATS	CAL/PTS	CARB	PROT	FATS	CAL/PTS

○ ○ ○ ○ ○ ○ ○ ○ ○ ○

Weight:

Sleep:

Vitamins/Supplements:

Daily Totals

CARB	PROT	FATS	CAL/PTS

After Exercise ▶

Daily Reflection:
..
..

○ My goal for today: SUN MON TUE WED THU FRI SAT **Day 74**

Date:

Exercise - Activity/Duration/Distance/Speed/Sets/Reps/Calories Burned

...
...
...
...
...
...
...
...

Breakfast	Lunch	Dinner

CARB	PROT	FATS	CAL/PTS	CARB	PROT	FATS	CAL/PTS	CARB	PROT	FATS	CAL/PTS

Snack	Snack	Snack

CARB	PROT	FATS	CAL/PTS	CARB	PROT	FATS	CAL/PTS	CARB	PROT	FATS	CAL/PTS

Weight:

Sleep:

Vitamins/Supplements:

Daily Totals

CARB	PROT	FATS	CAL/PTS
After Exercise ▶			

Daily Reflection:
...
...

Day 75

○ My goal for today:
...

SUN MON TUE WED THU FRI SAT

Date:

Exercise - Activity/Duration/Distance/Speed/Sets/Reps/Calories Burned

..
..
..
..
..
..

Breakfast

......................................
......................................
......................................
......................................
......................................
......................................
......................................
......................................
......................................
......................................
......................................
......................................

CARB	PROT	FATS	CAL/PTS

Lunch

......................................
......................................
......................................
......................................
......................................
......................................
......................................
......................................
......................................
......................................
......................................
......................................

CARB	PROT	FATS	CAL/PTS

Dinner

......................................
......................................
......................................
......................................
......................................
......................................
......................................
......................................
......................................
......................................
......................................
......................................

CARB	PROT	FATS	CAL/PTS

Snack

......................................
......................................

CARB	PROT	FATS	CAL/PTS

Snack

......................................
......................................

CARB	PROT	FATS	CAL/PTS

Snack

......................................
......................................

CARB	PROT	FATS	CAL/PTS

Weight: _____

Sleep: _____

Vitamins/Supplements:

Daily Totals

CARB	PROT	FATS	CAL/PTS

After Exercise ▶

Daily Reflection:

...
...

○ My goal for today:

Date:

SUN MON TUE WED THU FRI SAT

Day 76

Exercise - Activity/Duration/Distance/Speed/Sets/Reps/Calories Burned

Breakfast	Lunch	Dinner

CARB	PROT	FATS	CAL/PTS

CARB	PROT	FATS	CAL/PTS

CARB	PROT	FATS	CAL/PTS

Snack	Snack	Snack

CARB	PROT	FATS	CAL/PTS

CARB	PROT	FATS	CAL/PTS

CARB	PROT	FATS	CAL/PTS

Weight:

Sleep:

Vitamins/Supplements:

Daily Totals

CARB	PROT	FATS	CAL/PTS

After Exercise ▶

Daily Reflection:

Day 77

○ My goal for today:
SUN MON TUE WED THU FRI SAT

Date:

Exercise - Activity/Duration/Distance/Speed/Sets/Reps/Calories Burned

..

..

..

..

..

..

..

Breakfast	Lunch	Dinner

CARB	PROT	FATS	CAL/PTS	CARB	PROT	FATS	CAL/PTS	CARB	PROT	FATS	CAL/PTS

Snack	Snack	Snack

CARB	PROT	FATS	CAL/PTS	CARB	PROT	FATS	CAL/PTS	CARB	PROT	FATS	CAL/PTS

Weight:

Sleep:

Vitamins/Supplements:

Daily Totals

CARB	PROT	FATS	CAL/PTS

After Exercise ▶

Daily Reflection:

Use a protective blotter page here when coloring
with wet media on the reverse side of page

Week 12 · Plan: What To Eat This Week!

	Breakfast	Lunch	Dinner	Snacks
Sat				
Fri				
Thu				
Wed				
Tue				
Mon				
Sun				

Shop!

- ○
- ○
- ○
- ○
- ○
- ○
- ○
- ○
- ○
- ○
- ○
- ○
- ○
- ○
- ○
- ○
- ○
- ○
- ○
- ○
- ○
- ○
- ○
- ○
- ○
- ○
- ○
- ○
- ○
- ○
- ○
- ○
- ○
- ○
- ○

Day 78

○ My goal for today:

Date:

SUN MON TUE WED THU FRI SAT

Exercise - Activity/Duration/Distance/Speed/Sets/Reps/Calories Burned

..
..
..
..
..
..

Breakfast	Lunch	Dinner

CARB	PROT	FATS	CAL/PTS	CARB	PROT	FATS	CAL/PTS	CARB	PROT	FATS	CAL/PTS

Snack	Snack	Snack

CARB	PROT	FATS	CAL/PTS	CARB	PROT	FATS	CAL/PTS	CARB	PROT	FATS	CAL/PTS

Weight:

Sleep:

Vitamins/Supplements:

Daily Totals

CARB	PROT	FATS	CAL/PTS

After Exercise ▶

Daily Reflection:

○ My goal for today:

SUN MON TUE WED THU FRI SAT

Day 79

Date:

Exercise - Activity/Duration/Distance/Speed/Sets/Reps/Calories Burned

...
...
...
...
...
...
...

Breakfast	Lunch	Dinner

CARB	PROT	FATS	CAL/PTS	CARB	PROT	FATS	CAL/PTS	CARB	PROT	FATS	CAL/PTS

Snack	Snack	Snack

CARB	PROT	FATS	CAL/PTS	CARB	PROT	FATS	CAL/PTS	CARB	PROT	FATS	CAL/PTS

Weight:

Sleep:

Vitamins/Supplements:

Daily Totals

CARB	PROT	FATS	CAL/PTS

After Exercise ▶

Daily Reflection:
...
...

Day 80

○ My goal for today: ..

SUN MON TUE WED THU FRI SAT

Date: ..

Exercise - Activity/Duration/Distance/Speed/Sets/Reps/Calories Burned

...
...
...
...
...
...

Breakfast	Lunch	Dinner

CARB	PROT	FATS	CAL/PTS	CARB	PROT	FATS	CAL/PTS	CARB	PROT	FATS	CAL/PTS

Snack	Snack	Snack

CARB	PROT	FATS	CAL/PTS	CARB	PROT	FATS	CAL/PTS	CARB	PROT	FATS	CAL/PTS

Weight:

Sleep:

Vitamins/Supplements:

Daily Totals

CARB	PROT	FATS	CAL/PTS

After Exercise ▶

Daily Reflection:

My goal for today: ☐SUN ☐MON ☐TUE ☐WED ☐THU ☐FRI ☐SAT **Day 81**

Date:

Exercise - Activity/Duration/Distance/Speed/Sets/Reps/Calories Burned

Breakfast	Lunch	Dinner

CARB	PROT	FATS	CAL/PTS	CARB	PROT	FATS	CAL/PTS	CARB	PROT	FATS	CAL/PTS

Snack	Snack	Snack

CARB	PROT	FATS	CAL/PTS	CARB	PROT	FATS	CAL/PTS	CARB	PROT	FATS	CAL/PTS

Weight:

Sleep:

Vitamins/Supplements:

Daily Totals

CARB	PROT	FATS	CAL/PTS

After Exercise ▶

Daily Reflection:

Day 82 ○ My goal for today: .. SUN MON TUE WED THU FRI SAT
Date: ..

Exercise - Activity/Duration/Distance/Speed/Sets/Reps/Calories Burned

..
..
..
..
..
..

Breakfast	Lunch	Dinner

CARB	PROT	FATS	CAL/PTS	CARB	PROT	FATS	CAL/PTS	CARB	PROT	FATS	CAL/PTS

Snack	Snack	Snack

CARB	PROT	FATS	CAL/PTS	CARB	PROT	FATS	CAL/PTS	CARB	PROT	FATS	CAL/PTS

Weight:

Sleep:

Vitamins/Supplements:

Daily Totals

CARB	PROT	FATS	CAL/PTS
After Exercise ▶			

Daily Reflection: ..
..

○My goal for today: SUN MON TUE WED THU FRI SAT | Day 83
... Date:

Exercise - Activity/Duration/Distance/Speed/Sets/Reps/Calories Burned

...
...
...
...
...
...
...

Breakfast	Lunch	Dinner

CARB	PROT	FATS	CAL/PTS	CARB	PROT	FATS	CAL/PTS	CARB	PROT	FATS	CAL/PTS

Snack	Snack	Snack

CARB	PROT	FATS	CAL/PTS	CARB	PROT	FATS	CAL/PTS	CARB	PROT	FATS	CAL/PTS

Weight:

Sleep:

Vitamins/Supplements:

Daily Totals

CARB	PROT	FATS	CAL/PTS
After Exercise ▶			

Daily Reflection:
...
...

Day 84

My goal for today: ...

SUN MON TUE WED THU FRI SAT

Date: ..

Exercise - Activity/Duration/Distance/Speed/Sets/Reps/Calories Burned

...
...
...
...
...
...

Breakfast	Lunch	Dinner

CARB	PROT	FATS	CAL/PTS	CARB	PROT	FATS	CAL/PTS	CARB	PROT	FATS	CAL/PTS

Snack	Snack	Snack

CARB	PROT	FATS	CAL/PTS	CARB	PROT	FATS	CAL/PTS	CARB	PROT	FATS	CAL/PTS

Weight:

Sleep:

Vitamins/Supplements:

Daily Totals

CARB	PROT	FATS	CAL/PTS

After Exercise ▶

Daily Reflection:
...
...

Week **13**	Plan: What To Eat This Week!

	Breakfast	Lunch	Dinner	Snacks
Sat				
Fri				
Thu				
Wed				
Tue				
Mon				
Sun				

Shop!

○ ○ ○
○ ○ ○
○ ○ ○
○ ○ ○
○ ○ ○
○ ○ ○
○ ○ ○
○ ○ ○
○ ○ ○
○ ○ ○
○ ○ ○

Day 85 ○ My goal for today:

SUN MON TUE WED THU FRI SAT

Date:

Exercise - Activity/Duration/Distance/Speed/Sets/Reps/Calories Burned

Breakfast	Lunch	Dinner

CARB	PROT	FATS	CAL/PTS	CARB	PROT	FATS	CAL/PTS	CARB	PROT	FATS	CAL/PTS

Snack	Snack	Snack

CARB	PROT	FATS	CAL/PTS	CARB	PROT	FATS	CAL/PTS	CARB	PROT	FATS	CAL/PTS

Weight:

Sleep:

Vitamins/Supplements:

Daily Totals

CARB	PROT	FATS	CAL/PTS

After Exercise ▶

Daily Reflection:

○ My goal for today:

SUN MON TUE WED THU FRI SAT Day 86

Date: ..

Exercise - Activity/Duration/Distance/Speed/Sets/Reps/Calories Burned

...
...
...
...
...
...
...

Breakfast				Lunch				Dinner			
CARB	PROT	FATS	CAL/PTS	CARB	PROT	FATS	CAL/PTS	CARB	PROT	FATS	CAL/PTS

Snack				Snack				Snack			
CARB	PROT	FATS	CAL/PTS	CARB	PROT	FATS	CAL/PTS	CARB	PROT	FATS	CAL/PTS

Weight:

Sleep:

Vitamins/Supplements:

Daily Totals

CARB	PROT	FATS	CAL/PTS
After Exercise ▶			

Daily Reflection:

...
...

Day 87

○ My goal for today: ..

SUN MON TUE WED THU FRI SAT

Date: ..

Exercise - Activity/Duration/Distance/Speed/Sets/Reps/Calories Burned

Breakfast	Lunch	Dinner

CARB	PROT	FATS	CAL/PTS	CARB	PROT	FATS	CAL/PTS	CARB	PROT	FATS	CAL/PTS

Snack	Snack	Snack

CARB	PROT	FATS	CAL/PTS	CARB	PROT	FATS	CAL/PTS	CARB	PROT	FATS	CAL/PTS

Weight:

Sleep:

Vitamins/Supplements:

Daily Totals

CARB	PROT	FATS	CAL/PTS
After Exercise ▶			

Daily Reflection:

○ My goal for today: ... 〔SUN〕〔MON〕〔TUE〕〔WED〕〔THU〕〔FRI〕〔SAT〕 **Day 88**
.. Date:

Exercise - Activity/Duration/Distance/Speed/Sets/Reps/Calories Burned

..
..
..
..
..
..
..

Breakfast	Lunch	Dinner

CARB	PROT	FATS	CAL/PTS	CARB	PROT	FATS	CAL/PTS	CARB	PROT	FATS	CAL/PTS

Snack	Snack	Snack

CARB	PROT	FATS	CAL/PTS	CARB	PROT	FATS	CAL/PTS	CARB	PROT	FATS	CAL/PTS

○ ○ ○ ○ ○ ○ ○ ○ ○ ○

Weight:

Sleep:

Vitamins/Supplements:

Daily Totals

CARB	PROT	FATS	CAL/PTS
After Exercise ▶			

Daily Reflection:
..
..

Day 89

○ My goal for today: ...
Date: ...

SUN MON TUE WED THU FRI SAT

Exercise - Activity/Duration/Distance/Speed/Sets/Reps/Calories Burned

..
..
..
..
..
..
..

Breakfast	Lunch	Dinner

CARB	PROT	FATS	CAL/PTS	CARB	PROT	FATS	CAL/PTS	CARB	PROT	FATS	CAL/PTS

Snack	Snack	Snack

CARB	PROT	FATS	CAL/PTS	CARB	PROT	FATS	CAL/PTS	CARB	PROT	FATS	CAL/PTS

Weight:

Sleep:

Vitamins/Supplements:

Daily Totals

CARB	PROT	FATS	CAL/PTS

After Exercise ▶

Daily Reflection:
..
..

○ My goal for today: ... [SUN] [MON] [TUE] [WED] [THU] [FRI] [SAT] **Day 90**
... Date:

Exercise - Activity/Duration/Distance/Speed/Sets/Reps/Calories Burned

...
...
...
...
...
...
...

Breakfast	Lunch	Dinner

CARB	PROT	FATS	CAL/PTS	CARB	PROT	FATS	CAL/PTS	CARB	PROT	FATS	CAL/PTS

Snack	Snack	Snack

CARB	PROT	FATS	CAL/PTS	CARB	PROT	FATS	CAL/PTS	CARB	PROT	FATS	CAL/PTS

○ ○ ○ ○ ○ ○ ○ ○ ○ ○

Weight:

Sleep:

Vitamins/Supplements:

Daily Totals

CARB	PROT	FATS	CAL/PTS

After Exercise ▶

Congratulations! You have made it through 90 days!
Keep it up and enjoy **The Best You Yet!**

15784841R00071

Made in the USA
Middletown, DE
21 November 2018